CEREMONY OF MEMORY

*New Expressions in Spirituality
Among Contemporary Hispanic Artists*

Curated by
Amalia Mesa-Bains, Ph.D.
Center for Contemporary Arts of Santa Fe
New Mexico

Cover image is a detail of *The Bedroom* by Eddie Dominguez

Plate photographs by Steve Denny (p. 34-35),
Ramon Guerrero (p. 23-23), Wolfgang Dietze (p. 26-27, 31, 32-33,
39, 41), Kitty Leaken/Riccardo Trombetta (cover, p. 28-29),
Frank Martin (p. 37), Joan Voivin (p. 20-21, 24-25).

Manufactured in Japan by Dai Nippon Printing Co., Ltd.

Project Managers: Cynthia Baca, Dominique Mazeaud

CCA Visual Arts Coordinator: Bobbe Besold

Catalogue Design: Webb Design Studio, Taos NM

Typography: WD Type, Taos NM

ISBN 0-929762-00-2

Center for Contemporary Arts of Santa Fe
PO Box 148, Santa Fe New Mexico 87504

T A B L E O F C O N T E N T S

EXHIBITION SCHEDULE

January 28 - March 4, 1989
The Lannan Museum
Lake Worth, Florida

March 17 - April 29, 1989
The Museum of Contemporary Hispanic Art
New York, New York

July 7 - September 5, 1989
Center for Contemporary Arts of Santa Fe
Santa Fe, New Mexico

September 19 - October 31, 1989
Museum of Art, University of Arizona
Tucson, Arizona

November 17 - January 21, 1990
Centro Cultural de la Raza
San Diego, California

February 15 - April 1, 1990
The Meadows Museum, Southern Methodist University
Dallas, Texas

April 13 - May 31, 1990
Mexic-Arte
Austin, Texas

June 15 - August 5, 1990
The Contemporary Arts Center
New Orleans, Louisiana

September 8 - November 3, 1990
The Yuma Art Center
Yuma, Arizona

February 9 - March 6, 1991
Art Gallery, Visual Arts Center, California State University
Fullerton, California

PREFACE & ACKNOWLEDGEMENTS

Robert B. Gaylor, Director
Center for Contemporary Arts of Santa Fe

CCA has undertaken an initiative over the last three years to develop programs which foster a greater understanding of outstanding new art work being created by minority artists, both male and female. Futhermore, we wish to reveal its cultural context and its relationship to "mainstream" contemporary art. The *Ceremony of Memory* is an exhibition which we feel has achieved these goals in our own region and also outside of it. In order to provide appropriate authenticity and authority to *Ceremony of Memory* we decided that working with a curator and scholars of Spanish Pan-American ancestry was essential.

Amalia Mesa-Bains and I met in 1986 when I heard and saw her slide lecture *A Ceremony of Memory* which included some of the artists in this exhibition. I proposed to her that we work together to develop a traveling exhibition of the same name. At that time there were no artists from the Southwestern United States included, so I sought out three artists (two from Texas, one from New Mexico) whose work was appropriate to *Ceremony of Memory*. These three plus nine from the original slide show are now the artists in *Ceremony of Memory*. The entire project has been a delight, especially the collaboration with Amalia Mesa-Bains, whose insights, knowledge and sensitivity have been invaluable in realizing *Ceremony of Memory*. The vision and quality of the artists and art work has been an inspiration.

Special thanks must go to Bonnie Clearwater, Director of the Lannan Foundation, for her encouragement and interest in *Ceremony of Memory* and to Ed Jones and Dr. Sibyl Jacobson at the Metropolitan Life Foundation. Also we are most grateful to Alberta Arthurs, Director of Arts and Humanities, Rockefeller Foundation.

This exhibition has been made possible through grants from:

The Lannan Foundation
The Metropolitan Life Foundation
(Museum grants for Minority Visual Arts Program)
The Rockefeller Foundation
Additional support was received from The National
Endowment for the Arts, Visual Arts Program,
and The New Mexico Arts Division

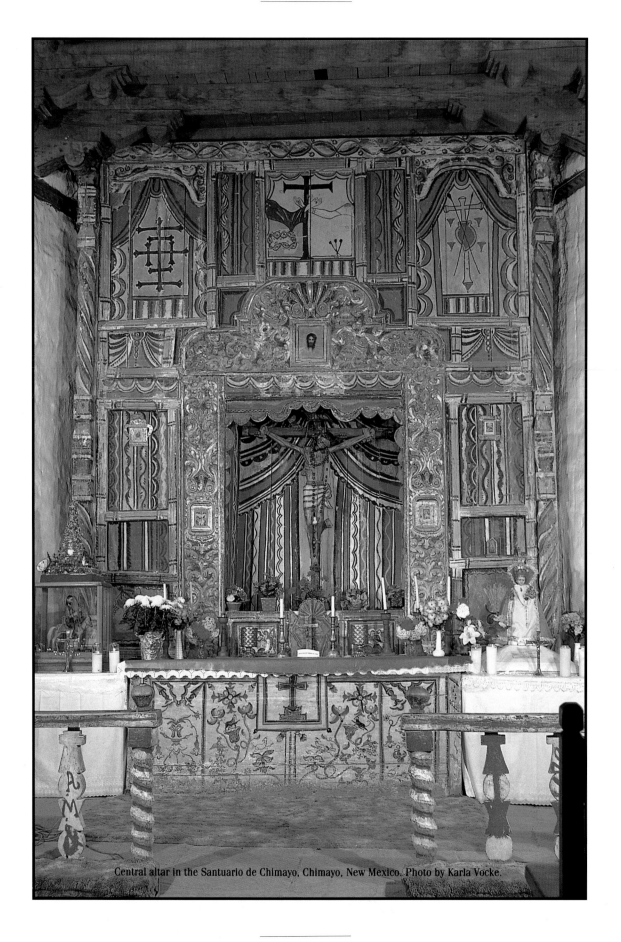

Central altar in the Santuario de Chimayo, Chimayo, New Mexico. Photo by Karla Vocke.

CURATORIAL STATEMENT

Amalia Mesa-Bains, Ph.D.

T he growing recognition of Hispanic art in America has revealed a need for clearer definitions and descriptions. Within this process of redefinition is the search for meaning and source. A primary impulse among Hispanic artists has been the spiritual, an expression of cultural memory. It is with the understanding of this cultural and spiritual expression that *Ceremony of Memory* attempts to circumscribe a genre of work in the larger field of Hispanic art.

The artists exhibited in *Ceremony of Memory* are of Chicano, Mexicano, Latino and Caribbean ancestry. They represent regions as diverse as Texas, New Mexico, California, Cuba, Uruguay, Puerto Rico and New York. Their experience in the United States is part of a continental and hemispheric context which has marked their art production. These artists share a cultural memory rooted in the Americas and this memory is displayed in imagery which fuses Catholic, indigenous and African elements. The reclamation of culture is also distinguished by the references to the personal and the past assembled and recollected in contemporary installation forms.

Ceremony of Memory explores the vital phenomenon of the ceremonial and spiritual art of contemporary Hispanic artists. The cultural forces at play in this growing body of work are reflected in both form and content.

The major forms within this phenomenon are shrine and altar installations, *nicho* box, *retablo* art and sacred objects such as fetishes and codice books. These forms have been the result of blends of pre-Hispanic, Yoruba and colonial religion and spirituality expressed in a popular arts tradition. Much of this work has been a response to the encounter between the everyday reality of Hispanic artists and the canon of fine art.

Within this genre of work is the aesthetic of fragmentation, recollection and ceremony. It is an aesthetic which springs from the experience of the emigre, the *curandero* and the lost devotional. In the experience of separation and expatriation lingers the sense of loss. Fragments of childhood secrets, cherished family rituals are recollected and joined with images, icons, and phenomenon.

Contained in this aesthetic is a cultural resistance expressed through the affirmation of an ancient worldview. The *Ceremony of Memory* brings together a number of contemporary Hispanic artists whose mixed media installations, shrines and box work uses icons, personal mementos, natural materials, folk art forms and installation techniques to express personal and historic themes.

Ceremony of Memory exhibits Chicano and Mexicano work distinguished by a cultural narrative. The regional Texas healing tradition, personal ceremonial memory and the colonial Baroque are all part of this narrative. In the hands of artists such as Peter Rodriguez, Carmen Lomas Garza, and Patricia Rodriguez these forms and images are extended and refined.

Peter Rodriguez's retablo boxes (page 41) enshrine the contemporary icons of the *Virgen de Guadalupe* and *Dia de Los Muertos calaveras* amidst painterly scenes of a dreamlike nature. Construction, assemblage, collage and miniature painting are elements in his mixed media work. His work is imbued with a folk ethos, yet it is expressed within a contemporary visual language.

The subtle and sometimes fragile qualities of the feminine are revealed in the *nicho* boxes of Patricia Rodriguez (page 39). Found objects, bits of fabric, veiled and screened openings and metaphoric messages characterize her box expressions. Rodriguez captivates with a sense of past lives and unrequited love in her carefully orchestrated codes of memory.

Critical to the cultural narrative among Chicanos has been work of Texas artist Carmen Lomas Garza (page

32-33). The *monitos* paintings of Carmen Lomas Garza recollect the richness of childhood memories as they document the cultural life of her regional Texas barrio. Lomas Garza's altar to Don Pedrito Jaramillo honors the healing traditions of her community. Lomas Garza, in her "Milagro" painting, takes us back to a childhood memory of virginal apparition, serpent images and community faith.

The iconography of *el chile, el corazon, la curandera,* and *la abuelita* are recombined and recomposed in ceremonial boxes. Confessional dialogues, devotional passions and modern day *milagros* are both object and icon in *nicho* box as well as paperwork.

The elements of satire, irony and critique are reflected in the world of Enrique Chagoya and Celia Muñoz. Chagoya's box art (page 26-27) blends the dualities of the ancient and technological through a miniaturized world view. His discerning eye views the traditional with amusement in unexpected compositions. The feminine mysteries become private secrets made public in the ironic photobooks of Celia Muñoz (page 34-35) as she traces her childhood confessions and feminine desire. *Chameleon,* her vanity mirror installation, retains an elegant minimalism as we venerate memories of dime store beauty.

Like a home altar, the sacred chamber is made personal in the tradition of bedroom dressertop altars in the work of Eddie Dominguez (page 28-29). Dominguez brings a high baroque sentiment to this ceramic bedroom installation which incorporates emblematic decoration of the Southwest.

In contrast to the scale of altar and shrine are the fetishlike sculptures of Maximiliano Pruneda (page 37). His work is imbued with the indigenous and ceremonial power of the magical object in its use of cloth wrapping, nails, sticks and bronze.

The *Ceremony of Memory* presents the contemporary art of the Americas which recollects the traditions of mysticism, shamanism, *santeria,* and ceremonial pageantry. The works of Caribbean artists graphically unite the power of ritual ceremony revealed and the remembrance of family celebrations. The work of Cristina Emmanuel (page 31) involves collage, drawing, found objects and *santeria* imagery to depict women's rites rarely disclosed. Her work is a mystical narrations in box and installation form. The iconography of the Greek orthodox is overlaid with the Puerto Rican pantheon in these female images.

The ritual tension between the Yoruba and Catholic traditions is present in the work of both Angel Suarez Rosado (page 43) and Juan Boza (page 20-21). The ancient, the African, the mythic and the magical are fragments recomposed in installations and performance work. Shattered pieces, the suitcase of the emigre, *orisha* and *ashe* mix and contradict in the art of the fantastic. Maria Brito-Avellana's sculpture installations (page 22-23) pursue the private in a form reminiscent of the small theatre of the Baroque. Time and space are redefined in her childhood memories as icons of the personal are held fast in modern day tableaus.

In a similar fashion the Baroque asserts itself in the iconography of Rimer Cardillo (page 24-25). His reliquaries of the fantastic with winged insects and colonial angels are repositories of martyred mysticism. Cardillo's accompanying printwork lends a quiet solitude to the power of the arcane as his icon constructions rest amidst the vestiges of the archeological.

All of these works are bound by a cultural past and present which have been formed by beliefs, practices and traditions of the Americas. In this sense, the range of nationality and region, iconography and form are tied by a continuity and consistency of experience. The works of these contemporary artists are guided by the intention to reveal, to recollect, to heal and to celebrate. Theirs is a recollection of fragments of personal history, narrative and worldview. Their art bears the experiential mark and is the *Ceremony of Memory.*

Amalia Mesa-Bains *received her Ph.D. from the Wright Institute, Berkeley. She is a nationally known artist working in the altar-installation form. Her scholarship and criticism has focused on cultural identity, spiritual expression and women's development among Hispanic artists. She is a curriculum specialist and lecturer as well as a community activist in the cultural arts. She is a member of the Board of Directors of the Galeria de la Raza in San Francisco.*

CULTURAL CONTEXT

Tomas Ybarra-Frausto, Ph.D.

Continental America remains a cultural "terra incognita," a vast newly charted space where the marvelous is encoded in the real. From the urban *barrios* of Manhattan through the Spanish-speaking southwest down through central and South America—to the very tip of Tierra del Fuego, there is a cultural continuum of people, cultures and beliefs. Everyday life practices throughout the Americas reflect admixtures of European, indigenous and African elements in kaleidoscopic modalities. Though ancient cultural traditions remain as root sources, dynamic new combinations emerge constantly.

The powerful and persuasive role of the Roman Catholic Church in shaping customs and institutions within Spanish-speaking communities is undeniable. Weaving in and out of folk beliefs and lore, the deeds and images of holy personages form a core of visual signification that is validated and understood by everyone within the "Hispanic" cultural heritage. Often the Catholic icons are intermingled with indigenous or African symbols in potently syncretic manifestations of religious belief.

Devils, angels, martyrs, virgins and saints symbolically recall their deeds while displayed in altars, shrines and sacred spaces devoted to worship, sacrifice and ritual. Such domains of belief are so powerful and persuasive that legions of academically trained "Hispanic" artists create art forms resounding with echoes, affinities and reworking of sacred and secular religious art forms found in Spanish-speaking communities.

NUTRIENT TRADITIONS: DOMESTIC ALTARS

The home altar and its function in Chicano everyday life is lyrically evoked by Silvia Nova Pena:
The house is silent and dark. In the far corner of the living room, the flickering lights of several tall votive candles illuminate a colorful assembly of plaster saints and religious lithographs, a Spanish Bible and an arrangement of family photographs. Kneeling before this rudimentary altar, a woman prays silently over her glass rosary beads. Her eyes, wet with tears in supplication are fixed upon an image of Our Lady of Guadalupe. Once she has finished the rosary, she addresses herself to the images on her altar, petitioning or thanking each of them.[1]

Whether arranged atop the television set, on a bedroom dresser, or in a specially constructed *nicho* (wall shelf), home altars are personal expressions of religious devotion and aesthetic vocation. Domestic altars serve as a point of connection and mediation between distinct domains, the terrestrial and celestial, the material and the spiritual, the personal and the communal. Created in a *bricolage* mode, constituent elements might include *recuerdos* (such as flowers or favors saved from some dance or party), family photographs, personal mementos, talismans and fetishes. *Santos*, religious chromos or three dimensional statues of saints especially venerated by the family, are the most significant components of the domestic shrine.

Altares often serve as a cumulative historical narrative for the life of a family. Their collection of photographs and objects spanning generations comment on the special events, tragedies and celebrations which are commemorated as life markers. Through the collection of memorabilia, prized *recuerdos* and decorative objects, *altares* provide a unique living record of the syncretic cultural reality of the Chicano family. The commingling of dimestore bric-a-brac, personal mementos, Mexican folk art, Catholic imagery and American tourist wares give the altar its dynamic visual integration.

The grouping of the multiple objects in an altar appears to be random but usually responds to the conscious sensibility and aesthetic judgement of what things belong together and in what arrangement, *altares* are organic

and ever-changing. They are environmental art forms that project an on-going ethno-spiritual statement. In their creative eclecticism, *altares* reverently display treasured objects deriving from significant events and occurrences in the life of their creators.

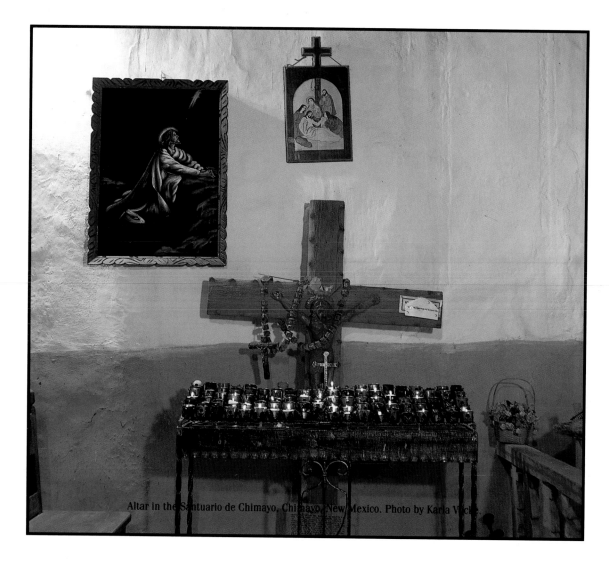

Altar in the Santuario de Chimayo, Chimayo, New Mexico. Photo by Karla Vick.

OFRENDAS: COMMEMORATIVE DAY OF THE DEAD ALTARS

Typically, altar offerings for Dia de Los Muertos *are assembled in the main room of the house upon the permanent altar which throughout the year displays images of saints along with candles, flowers, vases and a bowl for burning incense. There are few hard rules governing arrangements, the principal objective is to please the returning souls.* Ofrendas *are generally personalized for the special tastes of the deceased. Photographs of the honored dead occupy a central position and sometimes their names or initials are spelled out with small fruits or nuts.*

Altars honoring children have skeleton toys, sugar skulls, candies and games like loteria. *Those honoring adults might feature the deceased's favorite brand of cigarettes, liquor or items of special significance during the life of the deceased.*[2]

While home altars function as an integral part of everyday life, *ofrendas* are not typically erected in Chicano homes as they are in Mexico. Within Chicano communities in the United States, the creation of *ofrendas* has been a part of the cultural reclamation program of the Chicano art movement. Commemorative *ofrendas* have become

integral parts of the *Dia de Los Muertos* (All Souls' Day) celebrations in museums, galleries and artists centers. Yolanda Garfias Woo, Peter Rodriguez and Manuel Villamor are among the noted practitioners of this ancient funerary tradition. These artists maintain the traditional form, content and function of the *ofrendas*. Other artists remain true to the spirit of the *ofrendas* but re-contextualize them in non-traditional contemporary expressions. In some localities, the *ofrendas* are communal creations composed from the offerings brought by community residents. These large scale, collectively created, ceremonial art forms are vital examples of mobile reinvented traditions.

In the creation of *altares* and *ofrendas* the personal idiom of the artists is guided by tradition. Objects are a fusion of prescribed elements such as religious imagery and personal talismans and mementos. The spatial arrangement and design is also based on custom with an aperture towards self-expression.

The essential nature of *altares* and *ofrendas* as devotional statements changes when they are separated from the socio-cultural nexus of their origin. Although still functioning as ritual, ceremonial forms, their elaboration in the structured setting of an art gallery, museum or community hall transforms the *altar* and *ofrenda* statements. In their new setting, they become examples of multivocal exchange mediating between tradition and change.

NICHOS Y CAPILLAS: OUTDOOR YARD SHRINES

A devotional tradition shared by Mexican Americans and Cuban American communities is the eleboration of yard shrines. These enclosures made from a wide range of materials in varied sizes and shapes are constructed to house a holy image and often embellished with flowers, lights and found objects. The *nichos* (niches) or *capillas* (small chapels) are generally constructed in the front yard facing the street as public testimonials of faith and devotion.

In a phantasmagoric interplay of natural and artificial elements, the *capillas* enshrine a holy personage especially venerated by the family whose yard it graces and protects.

From simple box or beehive structure to eleborated construction with waterfalls, neon light and even piped-in music, the *capillas* recall the ancient wayside shrines where pilgrims could pause for rest and introspection.

CAJAS: BOXES

The enshrinement of talismans, fetishes or power objects in containers stems from the ancient Christian tradition of *reliquaries*. These were venerated religious items such as a supposed thorn from the crown of the crucifixion, a piece of the true cross or vials of blood or mummified anatomical parts of a holy personage displayed behind glass in eleborate containers. As worshipers touched or venerated them, their "aura" or power was transformed to the supplicant.

While not stemming from a folk tradition, many Mexican American artists have chosen to work in the *"caja"* form to eleborate autobiographical or cultural narratives fusing personal power objects with religious iconography.

Specifically religious *cajas* are inspired by traditional *nichos* (box enclosures with three dimensional depiction of saints and their specific accouterments). Like the *nichos*, modern *cajas* can function as small portable altars—(intimate and compact meditational spaces).

Non-religious *cajas* are generally mixed-media accumulations with a narrative impulse. Evoking and marking special moments and events in the lives of their creators, they become collective stories through the disposition of folk art artifacts such as toys, religious chromes and the inclusion of family photographs, personal fetishes and memorabilia.

Cajas are especially delightful in their repeated utilization of miniature objects and the elaboration of tiny tableaux. The diminutive, self-contained world within the *cajas* is generally composed of personal talismans

mingled with objects of collective cultural significance. Functioning as containers of belief, *cajas* serve as visual confluences of personal autobiography and group values.

INDIGENOUS AND AFRICAN ROOTS

The nutrient cultural forms of devotional art that undergird contemporary expressions of the spiritual within "Hispanic" communities derive from and are embedded within a cultural matrix with two basic admixtures—the Christian Indigenous and the Christian African.

In regions with a strong indigenous substratum, primordial belief systems and representations of ancient gods and goddesses are intermingled with Roman Catholic symbology and rites. The Christian altar was often planted over pagan sites of worship and today one is never certain whether the faithful venerate the altar or the idols buried beneath it. This living matrix of indigenous belief and practices is still so potent that it often seeps to the surface and is manifested in many modern rituals and liturgies that interface Christian and Indigenous worldviews. Across time, space and history, the cult of the Virgin of Guadalupe exemplifies this confluence. She is both Tonantzin the ancient goddess of fecundity and regeneration, and Mary the Mother of God.

In sections of the Spanish-speaking world with strong African presence and patrimony, religious practices from *vodum* and *santeria* interpenetrate Roman Catholic ceremonies and symbologies creating shifting new patterns of belief. Of major significance is the fusion of Yoruba deities into the pantheon of Catholic saints. The syncretic joining of symbols and attributes charges each religious figure so invested with doubly powerful and miraculous authority. Such distinct parrellelism and juxtaposition though widespread, is not consistent and varies across regions.

Creative reorganization of traditional religious systems from Indigenous and African religions continue in a dynamic process throughout the Spanish-speaking world. Within the United States, artists accentuating spiritual domains re-examine, reinterpret and redefine ancestral religious forms with multiple impulses; as counterparts to socio-political commentary, as symbolic and iconograhic systems united to autobiographical exploration or as primal icons that illuminate and foreground social conditions. Contemporary artists reworking spiritual canons augment their power and beauty. New forms of spirituality reverberate with the presence and potency of an ancient living ethos expanded with modern signification.

AN AESTHETIC OF DISPLAY AND ACCUMULATION

Resurrecting, repositioning and recontextualizing multiple cultural modes and modalities from inherited spiritual traditions, contemporary "Hispanic" artists postulate bold artistic statements resonant with past and present ideals. In numerous variations of cultural syncretism, an aesthetic of accumulation and bold display prevails.

Bits and pieces from varied cultural sources are joined and juxtaposed in stunning and startling combinations that reflect the bicultural/bilingual lived reality being expressed. Constituent elements are refracted in multiple repetitions, space is filled with baroque abandon and all elements are arranged for an emphatic declamatory impact. Variations in scale, interplays of colors, textures and patterns, intermingling of personal and culturally resonant artifacts, and a preference for ornamentation and theatrical presentation predominate. A prime strategy is to dazzle the eye and exalt the spirit.

Embedded in the overt proclamation of religiosity, hidden unobtrusive objects and talismans of spirituality abound. Feathers, shells, stones, bones and similar consecrated "power objects" are fused with Christian religious symbols and icons in apparent randomness but actually respond to an acute sense of allocation and arrangement.

As sanctuaries of the spirit, contemporary devotional art forms underscore the healing function of art. Spiritual creations attempt to heal the wound or cleavage in modern society between the terrestrial and celestial

domains. Devotional art is the symbolic terrain where artists commemorate and honor the spiritual component of our lived experience. Creation becomes a penitential devotion for the artist, a ceremony of memory exploring, narrating and attempting to reconcile the orbits of the mundane and the sacred.

SPIRITUAL MANIFESTATIONS AND CULTURAL NEGOTIATION

Inscribed within multiple cultural and historical traditions, "Hispanics" within the United States have activated complex mechanisms of cultural negotiation, a dynamic process of analysis and exchange of options between cultures. For example one might choose to speak Spanish, English or a combination of the two, the choice being predicated on a precise goal sought in a particular social situation. What is vigorously defended is a choice of alternatives.

In examples of spiritual art forms, the process of cultural negotiation is variously deployed. At the level of iconography and symbology for example, the "Hispanic" artist often creates a personal visual vocabulary freely blending and juxtaposing symbols and images culled from African, Indigenous, European and *Mestizo* cultural sources resonating with the power ascribed to the symbol within each culture. The new combination emerges dense with multifarious meaning.

Beyond symbols, artistic styles and art historical movements are continually appropriated and recombined in a dynamic and richly nuanced interchange. The constellation of expression in the Ceremony of Memory can be read as a visual narration of cultural negotiation. Through multiple aesthetic strategies these art forms delineate an expanding and exciting range of formal and thematic concerns. Contrary to a generalized apocalyptic sense of decay and closure prevalent in dominant art practices, these artists project energetic re-codings of multi-cultural traditions that posit new channels for communication and understanding.

Contemporary *Latino* art forms usually project the cadences of lived experience. Everyday life practices posit cultural boundaries as mobile, permeable and shifting. Cultural forms themselves encode historically derived options of revival and invention.

Current spiritual expressions both echo and transform established forms of religious art. Compellingly interfacing popular and orthodox religious practices through modernist techniques of *collage, bricolage* and performance strategies, *Latino* artists expand spiritual statements to assert cultural and self-fashioning. The form, content and meaning of recent spiritual art forms derives from a lively exchange and cross-cultural negotiation between a vast range of religious literary and visual art forms found in *Latino* communities. Cultural production does not reflect the symmetry of homogeneity but rather the irregularity of heterogeneity and hybridization. Fragments of archaic, ancient symbolism are interwoven with contemporary political use of religious iconography in spiritual statements of potent syncretism. Accumulated aggregates of still powerful religious traditions are inventively mined to project fresh unbound visions of belief.

The visual narrative being articulated is an emerging discourse of recollection and invention of tradition and change, of conversion and survival.

[1] Silvia Novo Pena, *Interiors: Secular Aspects of Religion* (Houston Texas: Houston Public Library, 1982).

[2] Robert V. Childs and Patricia Altman, *Vive Tu Recuerdo Living Traditions In The Mexican Days of the Dead.* (Los Angeles California: Museum of Cultural History, monograph Series Number 17, 1982).

Tomas Ybarra-Frausto *received his Ph.D. from the University of Washington in 1979. His scholarship and criticism touches on a wide spectrum of Chicano expressive culture including art, music, literature, theater and cinema. With Joseph Sommers he edited* Modern Chicano Writers: A Collection of Critical Essays *(1979) and with Shifra Goldman he compiled* Arte Chicano: A Comprehensive Annotated Bibliography of Chicano Art, 1965-1981 *(1985). Presently an Associate Professor of Spanish at Stanford University, Dr. Ybarra-Frausto is also Chairman of the Board of the Mexican Museum in San Francisco.*

CONTEMPORARY COMMENTARY

Victor Zamudio-Taylor

Self-consciousness in the process of transculturation is a major driving force as well as aesthetic in contemporary Latino art. This self-consciousness is both a personal-spiritual and social-political statement about the heterogeneity and richness of what constitutes the Latino identity across time. Lived experience and its aesthetic transfiguration in art, contests and indicts the ideology of acculturation or assimilation to the dominant culture and of deculturation or loss of cultural specificity.

The origin of the process of transculturation in the making of Latino culture lies in the encounter between the cultures of the new and old worlds. Along with genocide, acute violence, extreme suffering and the institutionalization of structures of domination, the paradigms of understanding, cultural practices, codes of behavior and religious beliefs of both cultures were profoundly transformed in the making of a qualitatively different culture. A new culture which Leon Portilla has referred to as one belonging to the "children of the encounter," one marked at the onstart by trauma, with open wounds and scars tattooed on its cultural corpus.

Transculturation in art itself signifies that the shared cultural past, rooted in the dynamic interplay of pre-Hispanic, African and European cultures is where artists search for forms to represent a collective history and lived experience in the United States. For what makes Latino art qualitatively different is precisely the use of an autonomous material and spiritual culture: lexicon, metaphors, iconography and forms in permanent dialogue and/or encounter with the dominant culture. From Pop Art, Conceptual Art, Minimalism to Neo-Expressionism these forms are transfigured, renewed and exploded to aesthetically realize what the specificity of the Latino experience needs and requires. Present intertexually in the debate and encounter is the celebration of Latin American art, from the colonial baroque and popular art to the work of the Mexican muralists, Kahlo and Matta as well as the political and experimental trends from the 1960s forward. Difference in contemporary Latino art is its renovating and vital drive: it is upheld and organizes its discourse.

THE PROCESS OF RECOLLECTION

In contemporary Latino art a remembrance of things past takes place in the process of creation and is meant to trigger the same in the reception of the work of art. A remembrance of the traumatic encounters which crystallizes hope in its evocation. This dialectic of creation and reception is a defining and defiant feature of contemporary Latino art. A "ceremony of memory" takes place: in the artist's creative process, in the work itself and in the viewer.

Recollection is the foundation and vehicle for the ceremony of memory. If, as Adorno wrote, forgetting is reification, then remembering is what makes the petrified world of everyday experience come alive. The forgetting of hardships endured just to continue living is accomplished in art as refuge and mere escape from reality. Remembering, in contrast, as an aesthetic principle, triggers and stimulates the conquest of suffering to make joy permanent. In this respect, the ceremony of memory recollects and evokes both encounters, confirming and reaffirming the contemporary Latino experience.

THE AESTHETICS OF FRAGMENTATION

Yet the past to be remembered as well as the present that is experienced is fragmented. History in the ceremony of memory is neither perceived nor represented as a continuum with a sense of telos. Colonization,

slavery, immigration and exile are circumstances that have marked and constituted the Latino experience. Yet the established discourse on history has justified and legitimized these conditions and events in the name of reason, progress and freedom.

The quest to unearth another version of both a personal and collective history to be transfigured artistically is characterized in the ceremony of memory by fragmentation. Fragmentation is an aesthetic as well as mimetic principle in contemporary Latino art. History is rendered in the works as a piling up of fragments, an accumulation of the debris and ruins from the first encounter onwards where a layering of the diverse cultures make up the Latino identity. Mixed media work such as installations, *altares* and *nicho* box works concretize the dialectic between form and content. In these works a contained exuberance contradicts the melancholy and horror of what is disappearing or has been forever lost from our culture in the age of postmodernity. That which is present then only in pieces or in absence is origin. Here the artists search and quote fragments to be reclaimed which maintain and explain difference. In this respect the aesthetics of fragmentation is a militant stance against the trends of emptiness celebrated in the arts disconnected from experience that rule the marketplace.

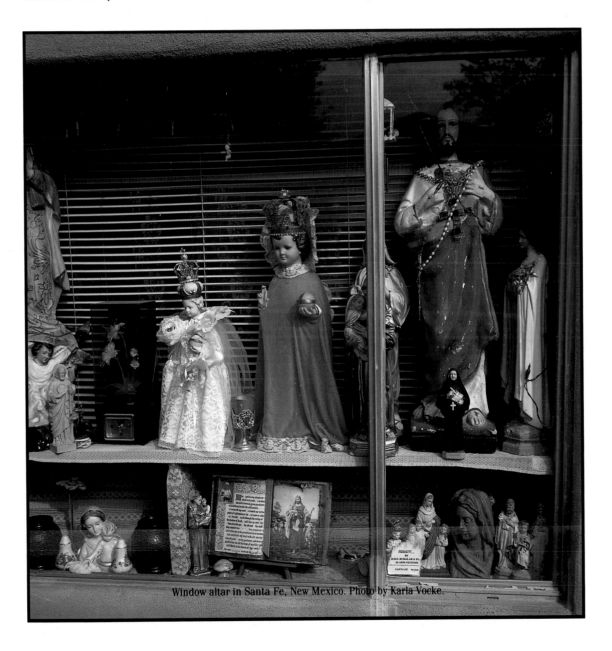

Window altar in Santa Fe, New Mexico. Photo by Karla Vocke.

THE DIMENSION OF THE SACRED

Thus in contemporary Latino art, and most so in the exhibition *Ceremony of Memory*, sacred and religious topoi and themes have been an explanation, a consolation and a refuge, secularized to serve as icons and vehicles to crystallize the Latino experience. In Juan Boza's *Installation* (Page 20-21), the exuberant layering and juxtaposition of signs of African and Catholic traditions create a particular syntax in which the fragments of the past in the form of relics are reclaimed as living pieces that celebrate the present, Boza is the artist as shaman whose work is ritual itself. There lies in *Installation* an anxiety and drive to create a new space of a sacred nature in a secular setting through a language and use of color charged with symbolism. *Installation* conveys a truth not to be uttered directly yet has a didactic mission: it seeks to recover sacred African-Catholic practices, which along with slavery, provides the ground in for the specificity of Black Latino culture.

Enrique Chagoya's *Nino de Atocha*, in contrast to Boza's *Installation*, carries to an extreme the use of religious lexicon to break the monopoly of the culture industry to define ritual and the otherness of experience. Nonetheless Chagoya recognizes the limits of the religious icon itself to do so alone. In *Nino de Atocha,* the miraculous boy savior of lost causes is postmodernized and becomes a fragment quoted in a tableau transfigured by nightmare-like dimensions of everyday life. Debris piles upon debris in the *Nino de Atocha* are magnified by the presense of death as life giver in the Baroque and Popular Mexican tradition.

In Chagoya's *Monument to the Missing Gods* (page 26-27), the use of prehistoric skulls and the miniature Coca-Cola folk art bottles constucts a complex metaphor in its minimalism. This metaphor of origin and transformation of Latino culture maintains a very ironic twist: the 80's iconography while nurturing itself with the pre-Hispanic past to criticize the banality of the present creates distance from the Chicano cultural of reclamation. The extended metaphorical use of such idealogically charged signs in Chagoya's particular syntax stops very short of creating an allegory of Chicano art and culture: Coca-Cola bottles are made divine and magical skulls of the pre-Hispanic ceremony of sacrifice are transformed into pop icons.

THE SOMATIC DISCOURSE

The aesthetics of fragmentation in the ceremony of memory is driven and ordered by that which the established reality and the traditional models for social change devalues and/or erases: the other and the otherness of experience. An otherness and other that include specificity and difference as well as the constructive elements that make up the inner history of individuals and the cultural autonomy of a collective experience. The transfigured language of transculturation in the ceremony of memory indicts the constructs of instrumental reason and the dominant culture evokes and creates images of an emancipatory reason, freedom and subjectivity that is other and is grounded in otherness.

In the aesthetic dimension of the works themselves another logic governs the discourse on subject object relations as anmesia and repression explode to unleash and trigger qualitatively different representations of anger, passion, desire and eros. To be sure, an emancipatory subjectivity is only represented, yet as images of emancipation there is a self-consciously constructed reception which makes those images acquire a permanence in the viewer. This permanence can potentially contradict the internalization of the established domineering culture in the subjective make-up of the individual. The materials that are transfigured aesthetically are collectively shared images, themes and topoi of a common identity and experience. It is here where one can situate the predominance of the somatic discourse in contemporary Latino art and more specifically in the ceremony of memory, as it is the body which is the ground for otherness.

The catalogue of body imagery and somatic concerns in the ceremony of memory draws from all the cultures that are constitutive of the Latino identity. From the pre-Hispanic and African to the new world baroque and popular culture, the body is a sign, a metaphor and allegory for the wounds inflicted on the corpus of our culture from the first encounter. Yet is is the battered body and the mutilated corpus of a shared tradition where

difference and specificity as well as resistance and change has and is to be grounded.

Art takes concrete individual and collective material from the established reality into another form of reality within its aesthetic dimension and through the realm of sensibility. Through transfiguration of everyday language and image, art communicates a reality where the body is the subjective counterpart of the fragmented history of which it is a part. Thus the body as theme and topos in the ceremony of memory, is characteristically, much like the baroque emblematic dictum, represented in pieces, wounded, fragmented with fissures, a shadow living to become a part of a whole.

Yet the whole, as far as the somatic is concerned, much like totality with respect to history, is absent and untrue. Maria Brito-Avellana's *Meanderings* death-mask like a portrait in stages of violent shattering works with the primordial lexicon of Eros and Thanatos. Its power lies in the unresolved struggle represented through absence of the body. What the viewer is left with is an emblem framed by dream and imbued with sinister qualities of the process of wreckage. The emblem sustains a deep and blurred reflection on the phenomenon that is to be accepted or changed. Or on the contrary, it represents the process of decomposition of the body into its negation: death. Rimer Cardillo's *Map and Fossil Box* evokes similar primordial desires in the dialectic fragment-whole but is focused towards the corpus of a shared tradition. The fragment is metaphorically the presence of something or may be all which once was. A memory is reified as it is made a thing encased appearing to belong to the Museum of Natural History. That is, when nature was not the object of domination of the subject. *Map and Fossil Box* communicates a truth as to the power of remembrance and recollection to order life along other experience repressed in the established reality. Like Brito-Avellana's *Meanderings, Map and Fossil Box* blurs direct interpretation and resolution to the point of containing its opposite. It expresses not only remembrance but also the overpowering amnesia that has made memory a faculty belonging to an extinct species of being and its realization a mere archeological endeavor.

In Cardillo's and Brito-Avellana's work the archaic, holds where otherness which plays and struggles against the disciplining of reason through the torn body and passion. What then appears to be just a reworking of the archaic and primordial material that makes up desire and religiosity, is in actuality, an indictment of the poverty of the dominant and domineering culture. Paradoxically, the archaic conveys new concerns driven by the quest to understand as well as to change through experience. If it is true that thinking is preceeded by suffering then thought which devalues or erases subjectivity has yet to cancel it. The lacerated body refutes reason in day to day experience. In two of Cristina Emmanuel's pieces, the dismembered body quoted in the form of talisman necklaces of metallic limbs, introduces and sustains transgressions within the internal dynamic of the works themselves. The juxtaposition of doll limbs on the narrative breaks violently with the threads that weave the text. Violence results from a constitutive anger and from the passion of a broken up interiority inflicted with wounds. In *Pague mi promesa como de debis . . .*, the garlands of body parts at first glance seem harmonic with the composition, yet the glance is subverted by the seductive gaze of transgressive desire enunciated in the piece. The strung fragments of the body, much like the baroque metaphor of the pearl as tear and wound, disturb the softness and tranquillity, an internal ruptures is created through juxtapostiion. This juxtaposition of mixed media produces a multiplicity of signification through indirect discourse. It is where the price of the promise lies. Thus what at first look was not a sign of violence and suffering is now loaded with immanent traces of extreme experience. In this respect, calling violence and suffering by its name through the metaphor of the dismembered body promises serenity as pain and anger are sublimated and overcome as catharsis.

In the religiosity involved in venerating relics as pieces that belonged to the blessed whole there is fetishism. Just as there is promise in the offering of an *ex-voto* that which was the object of healing through divine aid or miracle, in Cristina Emmanuel's work the fragmented body is a sign that a cure is at work. *Ex-votos* and relics are then secularized as signs of a transformed subjectivity that in turn grounds and contributes to radical change in subject object relations. In *Etapas*, a similar project and formal realization is at work. A tableau inspired by

popular familial arrangement of memorabilia is again transgressed by the fragmented body. The stages represented are violently leveled by the garland of limbs which break short and progressive, concise and clear syntax of the iconography. A dimension of transcendence is then revealed where images of a personal inventory and history appear in a discourse with the imperative to transform reality. An imperative voiced from the profound somatic damage done as well as the drive to make the somatic a constitutive basis for liberation.

THE TRANSFIGURATION OF MEMORY

The ceremony of memory shatters the reified universe and breaks the monopoly of the established discourse to define what is real and true. Perception is transfigured and a new universe is opened. Memory is perceived in order to undo and cure the wounds of social amnesia. The ceremony created images of the other and otherness to affirm and evoke that another universe is possible and that in fact, it is only possible in the remembrance of things past. In the ceremony of memory fragmentation permits subject and object, individual and collective history to appear freely and autonomously. Appearance is revealed as truth. The ceremony of memory opens a dimension of truth denied in lived everyday life. Yet the ceremony suffers no guilt when reflection and joy overpower and overcome suffering through memory: it re-collects, re-presents and reveals a horizon of experience and history that is still open.

Victor Zamudio-Taylor *is a Ph.D. candidate at Princeton University in the Department of Romance Languages and Literature. His scholarship and criticism have been focused on aesthetic theory and its application in contemporary culture. He is currently a Ford Foundation fellow involved in a dissertational study of 16th and 17th century Mexican literature and culture: religious theatre spectacles and mentality.*

THE PLATES

M *y artwork is anthropological, full of devotion, evocative of spiritual and magical forces and visions. It expresses the origins of my ancestry and the fascinating blend of Christian and African beliefs as Santeria. Through color, cloth, shells, feathers, beads, fruit and fetishistic objects and ornamented artificial foliage I depict the spiritual universe as essential to well being.*

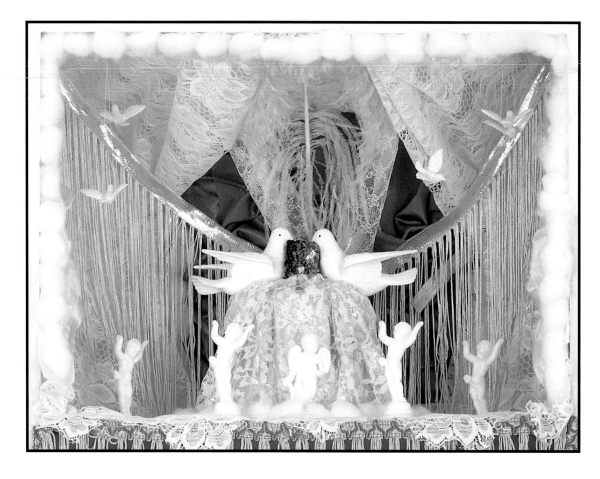

The Beginning and End (detail above), 1987
Mixed media installation
68″x21″x13½″

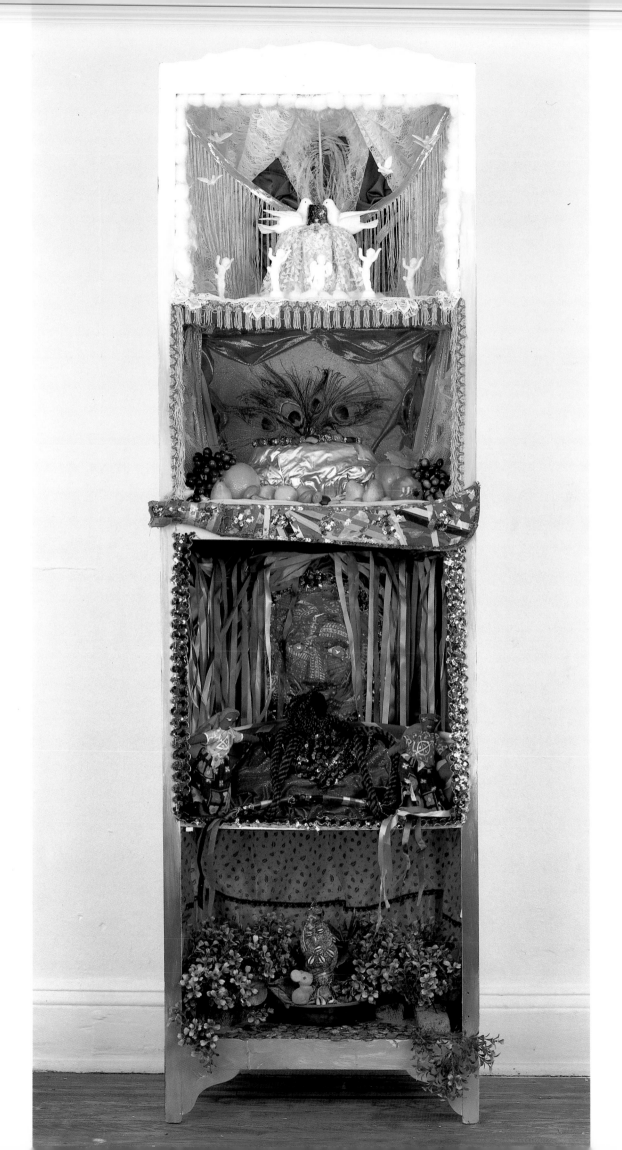

I n my work I explore both the personal and collective subconscious, and the seemingly absurd occurrences and imagery of the dream state. Color, used symbolically and/or to help create the illusion of space, has become an important element in these sculptures. Also, recent work with metal is channeling my interests toward its use in future works suitable for the outdoors.

Come Play With Us (detail above), 1985
(Childhood Memories)
Mixed media
80"x48"x53"

I have been very attracted to ancient and sacred spaces and temples, Gothic cathedrals and the archaic cities of Peru and Mexico. I have investigated the roots of civilization in Latin America and their relationship to European civilization. My work incorporates this cultural history which includes the memory of ancestors including those who have died in Uruguay for political reasons. Distance has given me a better perspective of the place where I was born. Although this distance has given me a new reality, my personal experience and my physical and visual memories most effect the nature of my work.

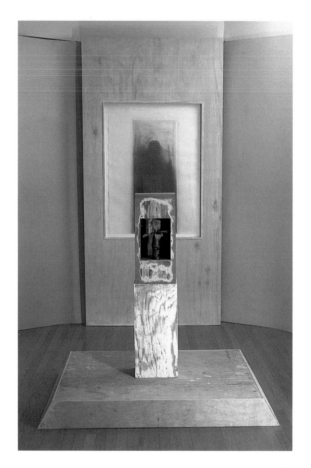

Isadora Altar, 1987-88
Mixed media installation
Red Signal, drawing, 42"x31"
Isadora, sculpture (right), 20½"x9½"x7"
Entire installation (above), 96"x49"x35"

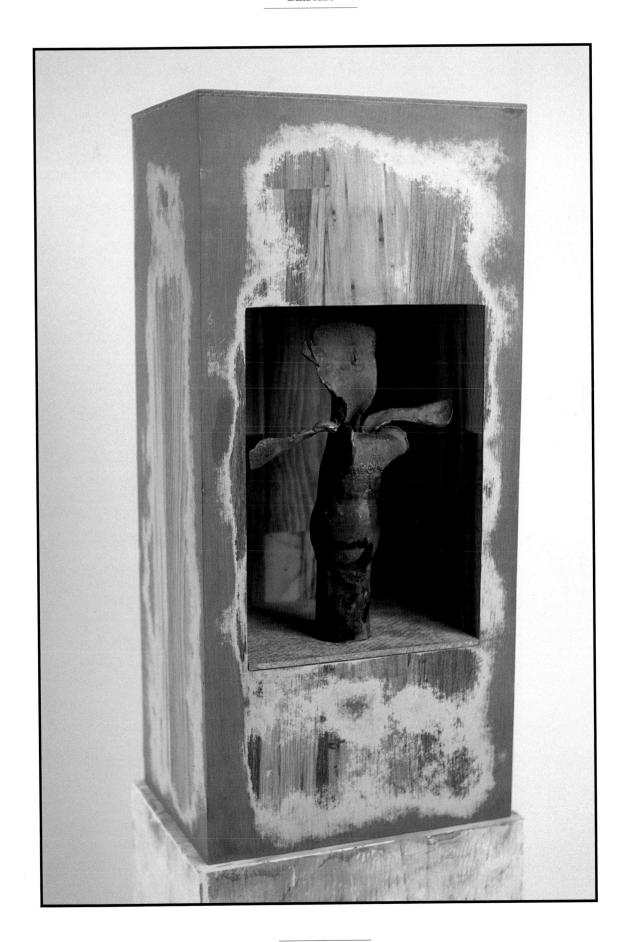

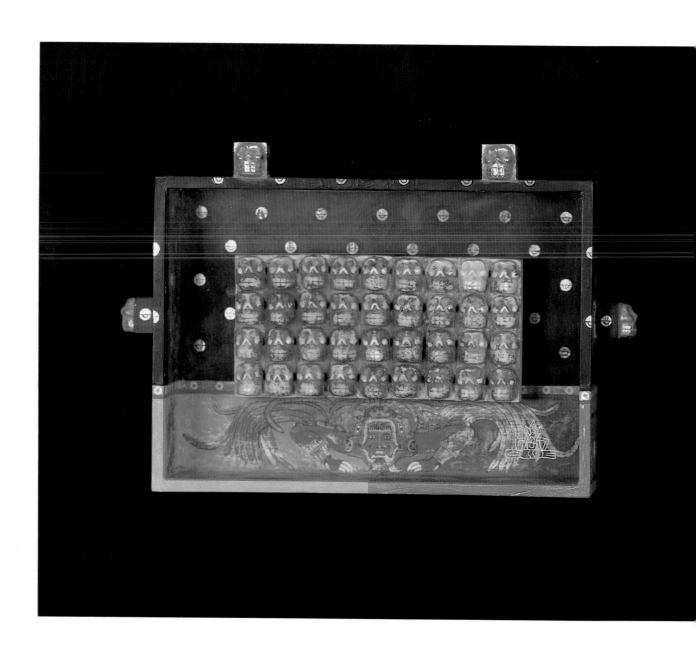

Monument to the Missing Gods, 1987
Mixed media
2 boxes, 9½"x14"x3½" each

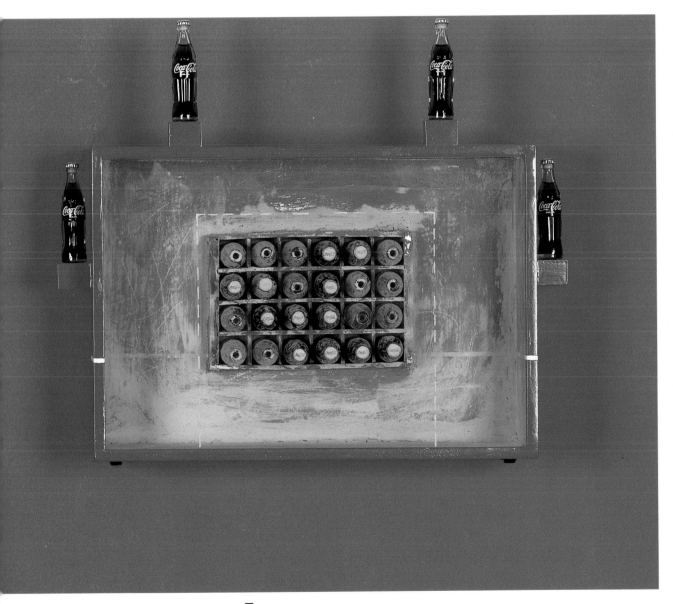

I am affected by the hidden truth in reality. This
essence is often the opposite of appearances. This
essence can be used as the raw material to elaborate
conscious and unconscious resolutions which become
the form of the work. There is an inherent freedom
in this process which allows form to follow spirit
and content.

EDDIE
DOMINGUEZ

I was trained as a ceramic artist but have always been interested in other areas of art. This has led me to become a mixed-media artist. It has been a dream of mine for several years to create a life-size bedroom installation in which I can control a complete environment, using objects that are familiar to, yet challenge the viewer. The bedroom project satisfies my need to make objects as large as life and also use contrasting materials and processes. The underlying intent of this work is the combination of purely aesthetic concerns with purely functional objects.

Important to my work is the continuous struggle to combine Hispanic art, folk art, contemporary crafts and fine art. It is this struggle that has inspired the relationship between objects. The work has become a collage of furniture, fiber, paint, light, metals and ceramics. In essence, the bedroom is a functional still life.

My vision was fantastic. Ideas always seem grand in thought. The finished art work then becomes a stepping stone to new visions. Reality, though not always so fantastic, brings its own rewards.

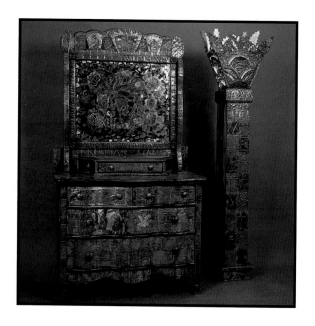

The Bedroom (two details), 1986-87
Mixed media installation
Includes bed, dresser, lamp & vanity
9'x11'x14'

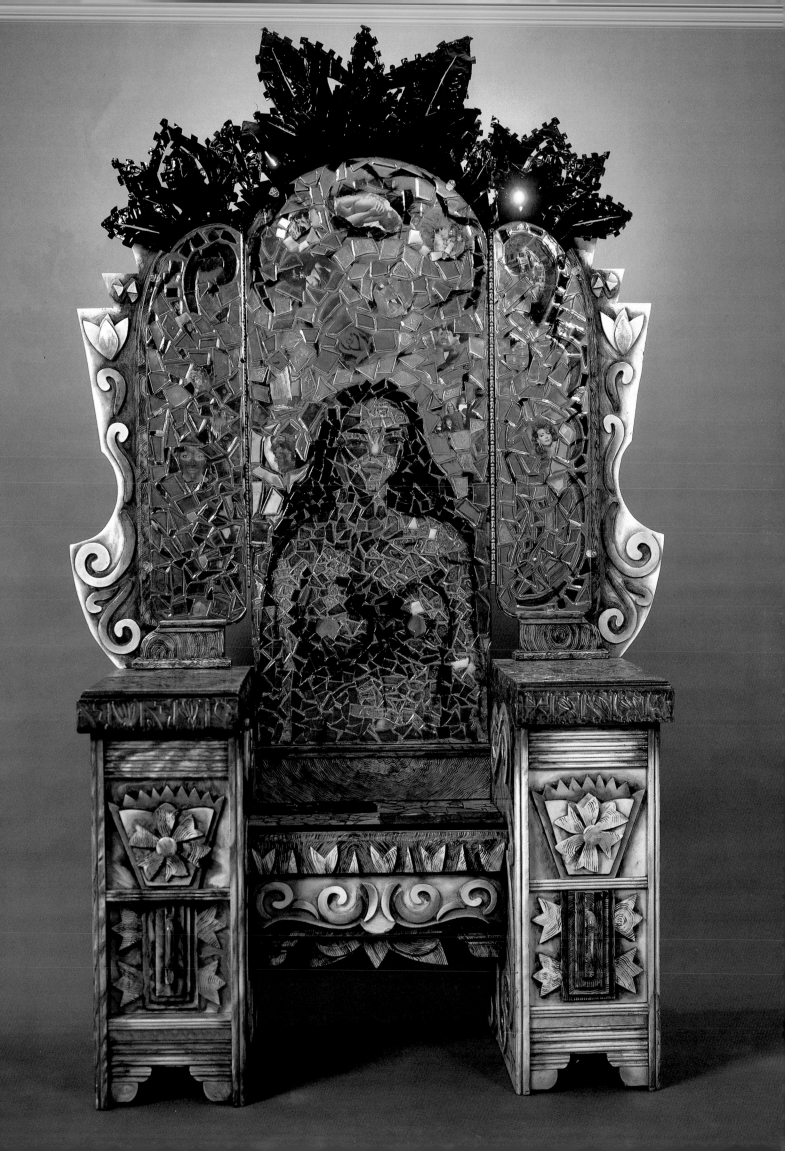

CRISTINA
EMMANUEL

T he images I use are really given to me, they come forth in my mind and clarify connections for me. There are collective elements whose meaning comes to me after even their creation. The Virgins and saints are part of my own empowerment and are not isolated in traditional associations. They are remythologized. Santa Cristina is not a martyr but a warrior and the Madre Dolorosa's suffering is a transformation, an opening of the heartspace.

Madre Dolorosa, 1985
Mixed media
45"x33"

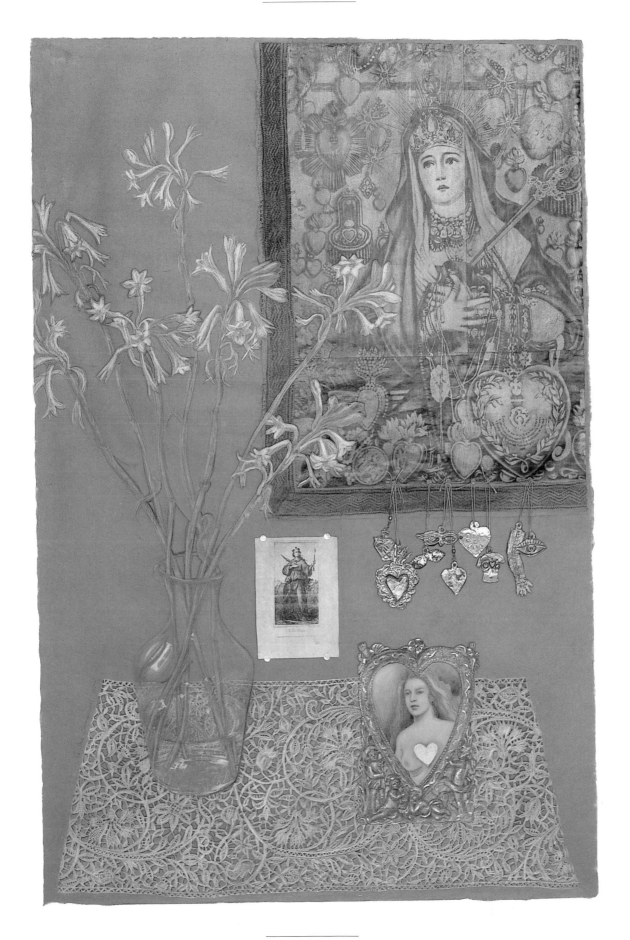

T here was a rumor going around the colonia that the Virgin of Guadalupe had appeared on a water tank in a ranchito not too far from town. So when we all got home from school and work my parents took us in the truck on a search for the ranchito. Some of us could see the Virgin in the water stains, others did not believe. Many people had been there all day praying and trying to make out the image of the Virgin. Instead of bothering the family of the ranchito some people had gone out into the fields to relieve themselves which alarmed the family. The rattlesnakes were a warning to people to be very careful when walking in the fields.

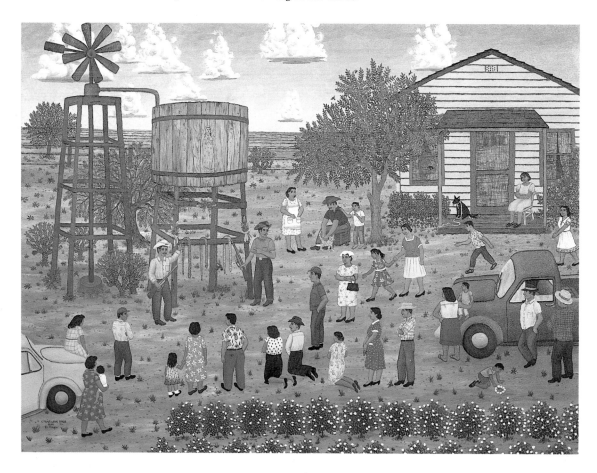

El Milagro (detail at right), 1987
Oil on canvas
36"x48"

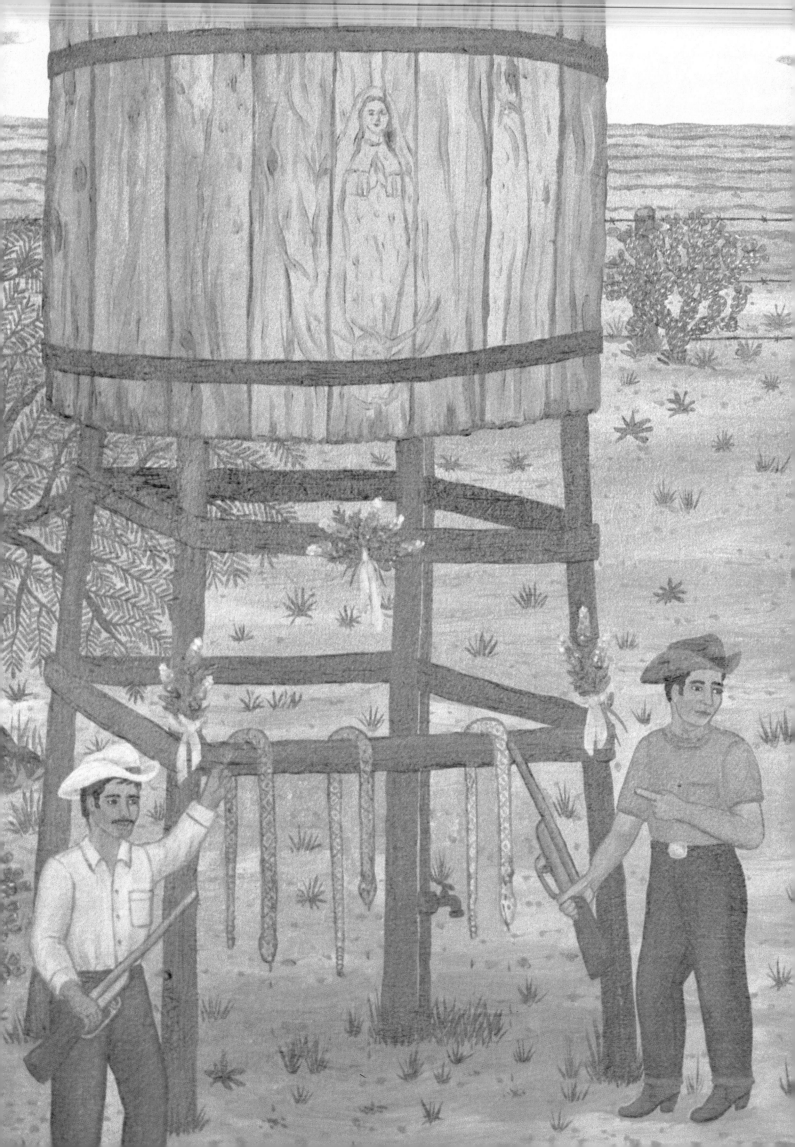

S tories your mother never told you
Visual lies, verbal truths or vice versa
Filmic, novelistic or invented approaches.
Comedy at the expense of somebody or something
Two languages, two thought processes, schizoid-type
All attempted to be articulated in visual or verbal or
conceptualized form
Either boxed-in or loudly painted in life-size or larger
forms.

The Toledo is the first installation
The Chameleon is the 2nd installation
Both I consider as extensions of the boxed pieces such as
"Ave Maria Purisima."

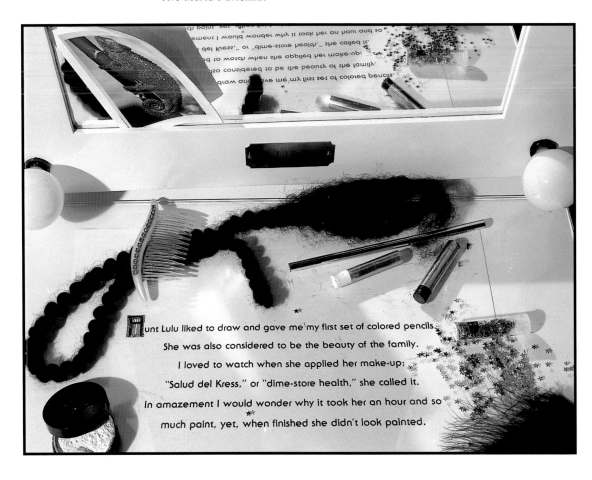

Chameleon (detail above), 1986
Mixed media installation
40"x20"x14½"

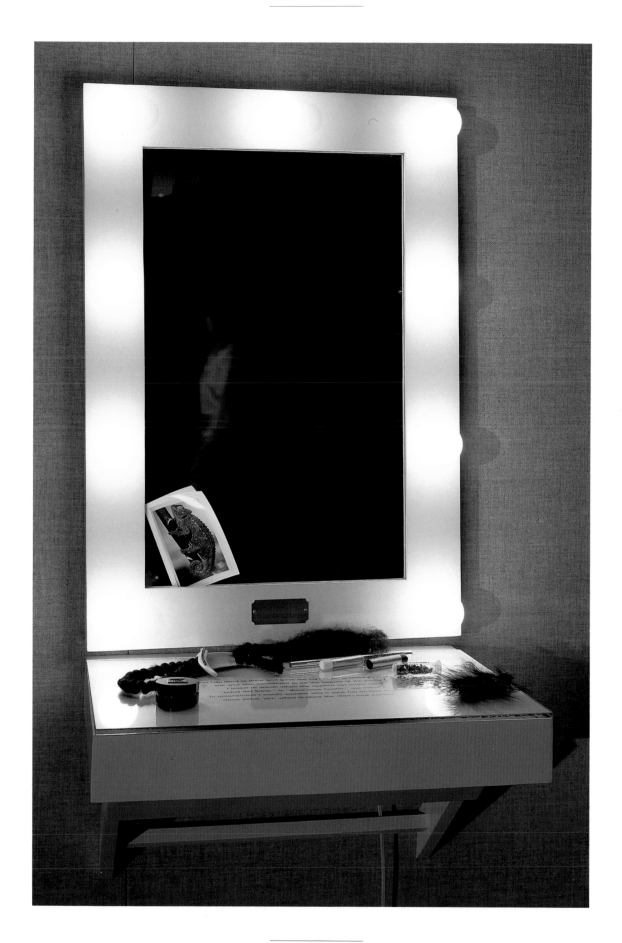

I n my work, the role of artist at times becomes that of channel, shaman, and ceremonial object-maker. I am engaged in creating images and objects that represent the idea of transformation through ritual. The objects become the elemental tools of magic: rattles, ceremonial staffs, effigies and totems that are essential to the idea of ritual. The primitive essence of this imagery is essential in evoking or linking the viewer with a sense of the past and primal memory.

Ghost Stick Carrier, 1988
Mixed media
35"x23"x14"

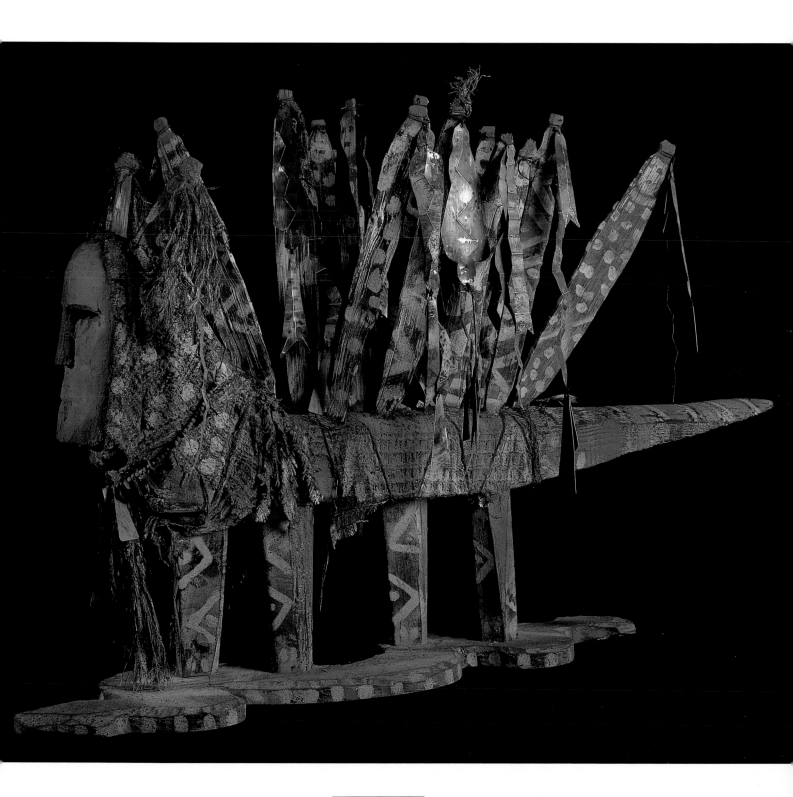

M y box constructions are an assemblage of hand-made and found objects, used in a composition to express belief patterns, myth, strange shrines, legends, the unconscious magic, love and war.

Dia de los Muertos, 1987
(Greener on the Other Side)
Wood/found objects
18"x13½"x4"

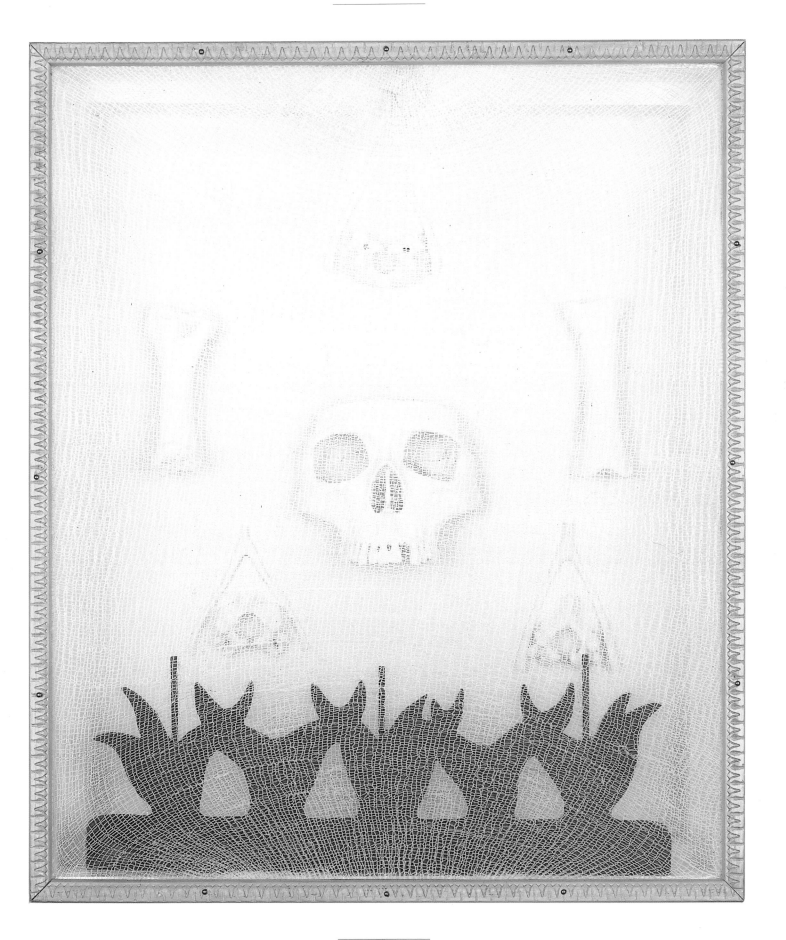

PETER
RODRIGUEZ

*I n many homes, altars are set up on a dresser or a
side table with images of saints that are venerated,
as well as photographs of deceased relatives and votive
candles. Shrines are also found in restaurants and other
commercial establishments. My cajas (boxes) are de-
rived from this tradition and the popular arts from both
Mexico and Mexican-American. I create the caja,
or box, using the folk tradition and popular customs, but
I do not try to duplicate them. My main concern has been
to take these traditions and incorporate them into con-
temporary terms. I have developed my boxes using folk
forms, found objects and painterly details.*

Chile Shrine, 1987
Mixed media
25"x14"x9½"

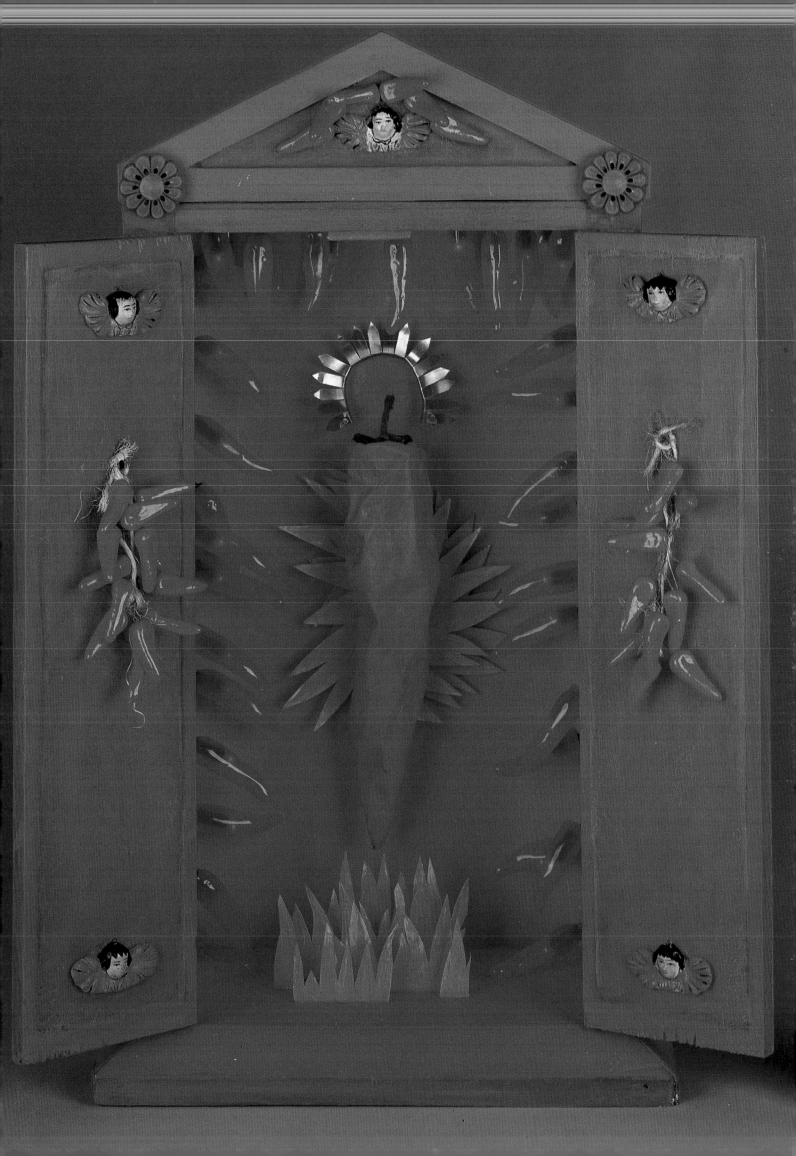

**ANGEL
SUAREZ ROSADO**

T *he popular belief of the lore of the* Virgen Del
Carmen *is celebrated on June 16, when ceremonies
and prayers still celebrate her fervor in most major
areas in Puerto Rico. I am studying the sacred spaces
that this tradition occupies, almost a clandestine space,
a zone of liberty, an awakened space.*

Virgen del Carmen, 1988
Altar/installation
Mixed media
74″x50″x55″

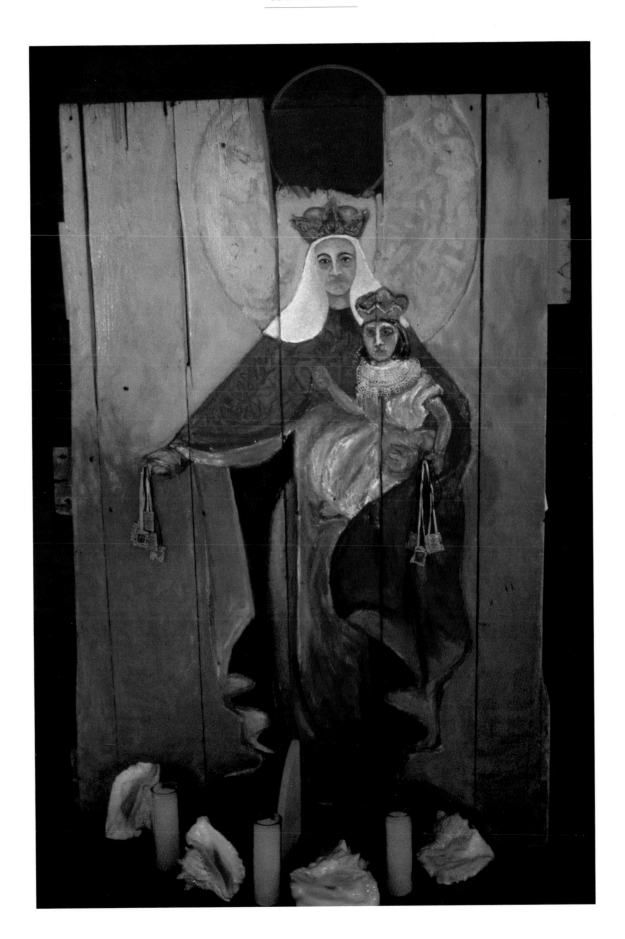

A B O U T T H E A R T I S T S

JUAN BOZA Mr. Boza was born in the plains of Cuba in an area knitted with fantastic legends and full of rhythms, dances and color, where emotion and nature mix spontaneously. His childhood revolved around the wisdom and awareness of this magic world. Later this magic world was not fantasy: it was a way of interpreting his emotions. The art became memories mixed with metaphor.

Since coming to the U.S. in 1980 from Cuba, Mr. Boza's work has become a continuous expression of the Afro-Cuban traditions and mysteries he knew during his youth. His drawings, paintings and sculpture have been influenced by *Santeria,* the Yoruba religious tradition practiced in Cuba.

EDUCATION: National Academy of San Alejandro, National Academy of Art and Experimental Art Print-making Workshop, Cuba, Printmaking Workshop, NY Lower Eastside Print Shop, NY, Art Students League, NY.

SELECTED EXHIBITIONS: *Fuera de Cuba/Outside Cuba,* traveling exhibition; *Fourth Latin American Graphic Arts Biennial,* MOCHA, NY; *Caribbean Art: African Currents,* Goddard-Riverside Center, NY; *Third Latin American Graphic Arts Biennial,* Cayman Gallery, NY; *Premio International de DiBuix Juan Miro,* Barcelona, Spain; *Venice Biennial; Eighth Joan Miro International Drawing Prize,* Barcelona, Spain; *Contemporary Cuban Painters,* Italian-Latin-American Institute, Rome, Italy; *International Prints XVIII, XIX, XX Century,* Museum of the National Autonomic Univ., Mexico City, Mexico; *Intergrafik '67,* Berlin, East Germany.

MARIA BRITO-AVELLANA Cuban born, Brito-Avellana's works reflect on the memories of childhood. Her wood sculptures are like intimate views of secret rooms where fragments of memory, masks, hands, hiding places are arranged in architectural settings. The personal and ceremonial quality of these quiet spaces is reminiscent of secret and mysterious enclosures.

EDUCATION: University of Miami, B. Ed.; Florida International University, M.S. Secondary Education; Florida International University, B.F.A.; University of Miami, M.F.A.

SELECTED GROUP EXHIBITIONS: *V Biennal Ibeoamericana de Arte,* Instituto Cultural Domecq, Coyoacan, Mexico; *Memories,* The Tampa Museum, Tampa, FL; *The Art of Miami,* Southeastern Center for Contemporary Art, Winston-Salem, NC; *NEA Fellowship Artists,* School of Visual Arts, Fine Arts Gallery, The Florida State University, Tallahassee, FL.

RIMER CARDILLO Uruguayan born, Cardillo's current imagery springs from a baroque colonial fascination with church or religious iconography. Baroque angels are blended with magical insect wings in precious reliquaries. The winged icons are held in secretive nature. Parallels are drawn between the pinned insects and martyred figures. Since 1958 Mr. Cardillo has been invited to participate in more than 50 international group shows and has become a well established and internationally awarded printmaker.

EDUCATION: Leipzig School of Graphics Arts, Germany; Weissenssee School of Art & Architecture, Berlin, Germany; National School of Fine Art, Uruguay, M.F.A.

SELECTED EXHIBITIONS: State University of New York, Purchase, NY; Museo de Arte Contemporaneo, Montevideo, Uruguay; Gallery 101, Malmo, Sweden; INTAR Gallery, NY; *Europe & the Third World,* Messepalast, Vienna, Austria; Premio Biella, Biella, Italy; Biennal de La Habana, Cuba; *8th British International Print Biennale,* Bradford, England; *World Print Four,* San Francisco Museum of Modern Art, CA.

ENRIQUE CHAGOYA Mexican born, Mr. Chagoya's work is a striking mix of the ancient and modern. His

small boxes trace the flourishing of the Mexican Nahuatl symbols and the objects of a contemporary society. Intimate and detailed, his boxes hold both a secretive and ironic view of social relations. Like miniature ruins, they contain windows, doors, mystical views of some remnant past. Meticulously painted with precise details, the boxes reflect the tiniest stage sets of a mysterious play unfolding.

EDUCATION: Universidad Nacional Autonoma de Mexico; San Francisco Art Institute, B.F.A.; University of California at Berkeley, M.F.A.

SELECTED EXHIBITIONS: Martin-Weber Gallery, San Francisco, CA; ASUC Studio, U.C., Berkeley, CA; Galeria de la Raza, San Francisco, CA; *VII Biennale of Latin American Printmaking,* Instituto de Cultura Puertorriquena, San Juan, P.R.; *Lo del Corazon: Heartbeat of a Culture,* Mexican Museum, San Francisco, CA; *What's Happening: Contemporary Art from the West Coast,* New Alternative Museum, NY.

EDDIE DOMINGUEZ Mr. Dominguez's work embraces signs of present and past within a passionately held pride for his ethnic roots. It also reflects a kind of generosity of spirit that approaches abandon as there are layers of implied meaning in his work, so too, are layers of form, His sculptures do not reveal themselves all at once. His work celebrates the personal geographic; it embraces the life of the body and the scenery within which that life is explored.

EDUCATION: Cleveland Institute of Art, B.F.A.; New York State College of Ceramics at Alfred Univ. NY, M.F.A.

SELECTED EXHIBITIONS: Allrich Gallery, San Francisco, CA; Roswell Museum and Art Center, Roswell, NM; Contemporary Craft Gallery, Portland, OR; New Mexico Arts Division Invitational, College of Santa Fe Gallery, NM.

CRISTINA EMMANUEL Ms. Emmanuel's work reflects the duality in her Greek Orthodox and Puerto Rican culture. Her box work expresses popular arts sentiment bound to memory and experience. Emmanuel's pieces elaborate a personal inventory where photos, *recuerdos* and *santeria* images are bound in mixed media presentation. The subtle illusion of drawing, xerox, collage, lace, and token amulets are part of an ongoing dialogue between desire and devotion.

EDUCATION: Goddard College, Plainfield, VT, B.A.; Vermont College, Montpelier, VT, M.A.

SELECTED EXHIBITIONS: *Cajas,* The Mexican Museum, San Francisco, CA; *La Cruz: Spiritual Source,* Galeria de la Raza, San Francisco, CA; Galeria del Municipio de San Juan, PR; *Nueve Mujeres en el Dibujo,* Galeria Espiral, Hato Rey, PR.

CARMEN LOMAS GARZA Ms. Lomas Garza's lithographs, gouache paintings and folk altars express a cultural narrative both personal and regional. The content of her works reflect the tradition of *curanderismo,* the folk belief system of healing. Her mixed media altar installations include *retablo* work, wall painting and assemblage. Her small boxes of copper work and painting, detail the image of the heart, Mexican, Catholic, indigenous. Ms. Lomas Garza's work centers on the depiction of a personal experience embedded in a regional cultural worldview.

EDUCATION: Bachelor of Science, Texas A & I University; M. Ed. Juarez-Lincoln/Antioch Graduate School, Austin, TX; M.F.A. San Francisco State University.

SELECTED EXHIBITIONS: The Mexican Museum, San Francisco, CA; The Museum of Fine Arts, Houston, TX; Galeria Posada, Sacramento, CA; San Francisco Museum of Modern Art, San Francisco, CA; *Altar Ego*, El Museo del Barrio, NY; *Mira,* de Saisset Museum, University of Santa Clara, CA.

CELIA ALVAREZ MUÑOZ The artist's works are a narrative of visual and verbal expression. A love of story-telling and books brought her to bookworks as an art form. Through them she reveals her bilingual and bicultural heritage: a schizoid type of existence from growing up in the border town of El Paso. She gently pokes fun at herself and her culture, referring to the works as ''enlightenment stories,'' because they help her to synthesize her own history.

EDUCATION: University of Texas at El Paso, B.A.; North Texas State University, M.F.A.

SELECTED EXHIBITIONS: *The Flower and Garden Show,* Invitational, DW Gallery, Dallas, TX; *Artists for*

Amnesty, Lubbock Arts Festival Gallery, TX; *Altars: Dia de los Muertos,* Bath House Cultural Center, Dallas, TX, *Chulas Fronteras,* Midtown Art Center, Houston, TX (traveling exhibition).

MAXIMILIANO PRUNEDA Mr. Pruneda's work is about the spirit and the ways in which this spirit manifests itself in this world. His main criterion in creating his totemic, fetish-like sculpture is not so much an explanation of aesthetics as the desire to express an image. He wants to make art that serves as a suitable container for a personal magic.

EDUCATION: University of Texas, Austin, B.F.A.

SELECTED EXHIBITIONS: *Houston Hispanic,* Museum of Fine Art, Houston, TX; *The East End Show,* Lawndale Art Annex, Houston, TX; *Chulas Fronteras,* Midtown Art Center, Houston (traveling exhibition); *Cowboys, Cadillacs and Computers,* Lawndale Art Annex, Houston, TX; *Director's Choice,* Galveston Art Center, TX; *Texas Fine Art Association Annual,* Laguna Gloria Art Museum, Austin, TX.

PATRICIA RODRIGUEZ Chicana painter and early muralist, Ms. Rodriguez has developed a genre of box art in the *nicho* or *retablo* form that juxtapositions intimate feminine portraiture, magical Catholic elements and tokens of love and loss. Using a combination of found objects, cloth, painting sculpture and enclosures, she creates both time and space. Like personal narratives, these boxes retrieve memories, storing them like private secrets.

EDUCATION: San Francisco Art Institute, B.F.A., Sacramento State University, M.F.A.

SELECTED EXHIBITIONS: *Vinculos,* Latin American Mysticism & North American Materialism, Whittier College, CA; *She,* Berkeley Art Center, CA; *From East to West,* MOCHA, NY; *Celebration of Sculpture,* 2nd Annual San Francisco Arts Commission; *Altar Ego,* de Saisset Museum, University of Santa Clara, CA; *A Traves de la Frontera,* Mexico, D.F.

PETER RODRIGUEZ Mexican American founder of the Mexican Museum, Mr. Rodriguez has long been an exponent of the folk arts. His appropriation of folk form has been recombined within a contemporary box form. The offertory boxes are exemplified in the *Virgen de Guadalupe* series. His assemblage (mixed media) blend traditional elements with a magical color sense, surreal painting context and the sensibility of a religious popular art. The *milagro* element and images such as *Dia de los Muertos* become part of a revival of the *retablo* tradition within a contemporary view.

EDUCATION: Stockton Community College, University of California, Berkeley (Museum Management).

SELECTED EXHIBITIONS: Texas University at Corpus Christi, TX; Phoenix First Annual Southwest Chicano Invitational Art Exhibit, Heard Museum, Phoenix, AZ; First Annual Hispanic American Art Exhibition, San Francisco Art Institute; Wing Luke Memorial Museum, Seattle, WA; Kaiser Art Center, Oakland, CA; Oakland Museum of Art; Tlalpan Exposition, Tlalpan, Mexico.

ANGEL SUAREZ ROSADO Mr. Suarez was born in Puerto Rico and moved to New York in 1979. Functioning as a modern shaman mediating between the spiritual and material realms, the artist utilizes ordinary materials as a means of contact with spiritual presences and forces. The material objects, natural, found, or fabricated are transformed into "objects of power" as they accrue symbolic density and meaning emanating from their accretion, arrangement and display. In a fluid bricolage mode, Suarez's installations are capable of infinite extension since constituent elements can be manipulated in various improvised combinations to generate new meanings with them. As sanctuaries of the spirit, the installations are at once primordial holy spaces and culturally specific reliquaries that precisely order, classify and arrange devotional objects from Afro-Caribbean religions and magical folk practices.

EDUCATION: School of Visual Arts, NY, B.F.A.; University of New York, Buffalo, NY, M.F.A.; Puerto Rican Studies, University of Puerto Rico, Rio Piedras, PR, Art History and Humanities.

SELECTED EXHIBITIONS: Altos de Chacon, Dominican Republic; Parsons School of Design; *Religious Iconography in Contemporary Hispanic Art,* INTAR Latin American Gallery, NY; Visual Arts Gallery, NY; Museo del Grabado Latino Americano; Cayman Gallery, NY.

E X H I B I T I O N L I S T

JUAN BOZA

1
The Beginning and End, 1987
Mixed media installation
68" x 21" x 13½"

MARIA BRITO-AVELLANA

2
The End of the World, 1986
Mixed media
37" x 31" x 25½"

3
Windows, 1985
Mixed media
14½" x 11½" x 2¼"
Collection of Juan Espinosa

4
Meanderings, 1985
Mixed media
33" x 59" x 18"

5
Come Play With Us, 1985
(Childhood Memories)
Mixed media
80" x 48" x 53"

RIMER CARDILLO

6
Isadora Altar, 1987-88
Mixed media installation
Red Signal, drawing, 42" x 31"
Isadora, sculpture,
 20½" x 9½" x 7"
Installation, 96" x 49" x 35"

7
Ancestral Box, 1987-88
Mixed media installation
Wood, metal, plaster,
 6" x 33" x 23"
Square of earth, 84" x 84"

8
Sanctuary, 1987-88
Mixed media installation
Wood, paint, lead, brick,
 27½" x 19" x 12"
Platform, 8" x 64" x 50"

9
Map and Fossil Box, 1985-87
Mixed media installation
Map, 41" x 54" (framed)
Fossil Box, wood, cotton, plaster,
 10" x 7" x 2"
Display stand, 43" x 19" x 19"

10
Reliquary and Nebulous Rites,
 1983-85
Mixed media installation
Nebulous Rites, monotype
 collage, 43" x 35" (framed)
Reliquary, wood, cotton, wax,
 pins, 5½" x 8" x 2"
Display stand, 48" x 27" x 27"

ENRIQUE CHAGOYA

11
Nino de Atocha, 1986
Mixed media
9½" x 14" x 3½"

12
Monument to the Missing Gods,
 1987
Mixed media
2 boxes 9½" x 14" x 3½" each

13
Vanished People, 1987
Mixed media
9½" x 14" x 3½"

14
Icon, 1987
Mixed media
9½" x 14" x 3½"

EDDIE DOMINGUEZ

15
The Bedroom, 1986-87
Mixed media Installation
Includes bed, dresser, lamp &
 vanity, 9' x 11' x 14'

CRISTINA EMMANUEL

16
Madre Dolorosa, 1985
Mixed media
45" x 33"

17
*Pague Mi Promesa Como
 Se Debia. . .*, 1983
Mixed media
35" x 15"

18
Santa Cristina, 1986
Mixed media
45" x 33"

19
Etapas, 1985
Mixed media/drawing
28" x 18½"

20
La Virgen de Lagrimas, 1988
Mixed media installation
96" x 48" x 20"

CARMEN LOMAS GARZA

21
El Milagro, 1987
Oil on canvas
36" x 48"
Collection of Mary-Frances
 Hernandez & Lorenzo R.
 Hernandez

22
Don Pedrito Jaramillo,
 1976-present
Mixed media installation
90" x 48" x 18"

CELIA ALVAREZ MUNOZ

23
Tolido, 1988
Mixed media installation
5'2" x 6'2" x 6'2"

24
La Honey-Enlightenment #9, 1983
Mixed media
Box and seven framed pages
12" x 17" x 14"
Collection of Lannan Foundation

25
Chameleon, 1986
Mixed media installation
40" x 20" x 14½"

26
Ave Maria Purisima, 1983
Mixed media
Opened box with frames
10" x 14" x 5½" each frame
Collection of Lannan Foundation

27
La Tempestad, 1985
Maple tryptich
Mixed media
24" x 52" x 1-¾"
Collection of Lannan Foundation

MAXIMILIANO PRUNEDA

28
Portal Dancer, 1988
Mixed media
39" x 19" x 16"

29
Power Rattle, 1986
Mixed media
22" x 6" x 3¼"

30
Boo Rattle, 1987
Mixed media
48" x 7" x 5½"

31
Ghost Stick Carrier, 1988
Mixed media
35" x 23" x 14"

32
Horned Transformation Charm,
 1987
Mixed media
52" x 4" x 3"

PATRICIA RODRIGUEZ

33
Heart Times, 1982
Wood/found objects
12" x 8" x 4"
Collection of Amalia Mesa-Bains

34
Dia de los Muertos, 1987
(Greener on the Other Side)
Wood/found objects
18" x 13½" x 4"
Collection of Roy Patlan

35
The Confessional, 1987
Wood/found objects
8" x 40" x 4"
Collection of Susan Maney

36
Reincarnation, 1983
Wood/found objects
15" x 12" x 4"

37
The Magic Hand, 1985
Wood/found objects
16½" x 22" x 12½"

PETER RODRIGUEZ

38
Dia de los Muertos, 1984
Mixed media
26" x 16" x 9½"

39
Lo del Corazon, 1983
Mixed media
27" x 15" x 7"

40
Milagros, 1987
Mixed media
26" x 16" x 9½"
Collection of Gloria Leader

41
Chile Shrine, 1987
Mixed media
25" x 14" x 9½"

ANGEL SUAREZ ROSADO

42
Virgen del Carmen, 1988
Altar/installation
Mixed media
74" x 50" x 55"

All works are in the artist's
collection unless noted otherwise.

G L O S S A R Y

abuelita the grandmother. A frequent image in Hispanic arts.

altares altars in the home where family memorabilia, religious statues and images are arranged with decoration and devotion.

ashe a spiritual power or command expressed or embodied in objects, animals or messenger.

barrios an urban Hispanic community or neighborhood.

bricolage arrangements of found objects in which meanings can change according to new combinations and placements.

cajas boxes used to contain objects, particularly miniatures in a reliquary sensibility.

calaveras refers to skeleton images, particularly skulls.

capillas a yard shrine named for a small chapel often a simple box or beehive structure constructed with waterfalls, road decorations, neon light and plastic flowers.

chile the chile pepper, an image associated with spicy, strong, sexual or enduring qualities.

corazon the heart often an image reverential to the sacred heart of Christ.

curandera a healer associated with a tradition of herbalism and indigenous belief.

Dia de Los Muertos a holiday connected to all Souls Day with indigenous roots. Families honor their dead with home altars, gravesite cleaning and decoration and celebration. This holiday is the source of a great deal of folk art.

loteria the lottery game, like bingo, played by families. The lottery cards are decorated with symbolic characters such as the devil, the cactus, etc.

mestizo people of mixed indigenous and Spanish ancestry.

milagros literally translated "miracles" or small amulets which signify the part of the body healed by prayer and divine intervention. Milagros are used to decorate the saints and to demonstrate gratitude.

monitos literally translated "dolls" or in reference to Lomas Garza's work, monitos are naive renderings of people.

nicho nichos or small wall shelves, sometimes a box enclosure with saints and decorations.

ofrenda an offeratory altar especially arranged for Dia de Los Muertos. Foods, drink and mementos of the departed are offered to the visiting spirit.

orisha deities in the Yoruba religious pantheon. These deities are specific parts or forces which govern parts of the universe.

recuerdo a remembrance or memento of an individual such as a belonging often used by the departed.

reliquaries relics or venerated religious items were enshrined in glass boxes for protection and display.

retablo a Mexican religious painting on tin (ex-voto) or painted wooden screen for a church.

santeria the veneration of saints in an Afro-Hispanic tradition. Ceremonial and healing practices associated with devotion to the saints.

santos statues or carvings of saints.

vodum traditional African religious practices.

Suggested Reading

Robert V. Childs and Patricia Altman, *Vive Tu Recuerdo Living Traditions In The Mexican Days of the Dead*. (Los Angeles, California: Museum of Cultural History, monography Series Number 17, 1982.)

Pat Jasper and Kay Turner, *Art Among Us - Arte Entre Nosotros, Mexican American Folk Art of San Antonio*. (San Antonio, Texas: San Antonio Museum Association, 1986.)

John Mason and Gary Edwards, *Black Gods - Orisa Studies in the New World*. (Brooklyn, New York: Thoruba Theological Archministry, 1985.)

Robert Farris Thompson, *Flash of the Spirit - African and Afro-American Art and Philosophy*. (New York: Random House, 1983.)